CONTENTS

FOREWORD

Once again we have both spent many happy hours full of laughter, enjoyment and creativity in making this, our second co-authored book. Here, we have used folding papers, cutting papers and matching stamps designed by Janet, to bring you projects reflecting Oriental and Celtic themes.

Try your hand at the age-old arts of folding a Ningjo doll, paper cutting, paper burning as well as paper architecture and paper embossing to make original and innovative projects to mount Tiny's new tea bag folds on to. We hope you all enjoy making the folds, cards, books, wind chimes and other projects as much as we enjoyed creating them.

We would like to thank Wieteke van der Plas, Henriëtte van Lunen, Lies Vleeschhouwer, Dorothy Hughes, Lynne Kaiser and a special thank you to Claudette Hunter and her English language students in Japan for all their help, encouragement and support.

Janet Wilson and Tiny van der Plas-van Nunen

GENERAL INSTRUCTIONS

Materials

Special papers Folding papers, cutting papers Sumi paper (Japanese calligraphy paper), graphite paper, tracing/parchment paper, thin metal sheet

Stock papers/cards Coloured paper, metallic paper thin coloured card, 3mm foam board, strong smooth board

Adhesives PVA glue, all-purpose glue, spray adhesive, cocktail sticks, double-sided sticky tape, masking tape, low-tack sticky tape, stapler

Other materials Gold ink, gold thread (Kusudama silk), ribbon

Equipment

Cutting Craft knife, steel-edged ruler, cutting mat, paper cutting scissors, general-purpose scissors, corner scissors

Stamping Rubber stamps (to match the folding and cutting papers), dye ink pads

Embossing Metal embossing stencils, embossing tools, plastic quilting wheel, high-density foam mat (mouse mat)

Paper burning Pyrography iron

Other equipment Pencil, lino roller (brayer), sponges, paint brush, gold gel pen, sponge, Sate sticks, brass curtain rings, lead curtain weight, Colluzle circle kit, wind chimes, cat bells, beads/flat faux jewels, wooden dowel, Japanese uchiwa (fan), cardboard photoframe, box-type picture frame

International origami symbols

A white diagram indicates that the back of the folding paper is uppermost.
A grey diagram indicates that the patterned side is uppermost.

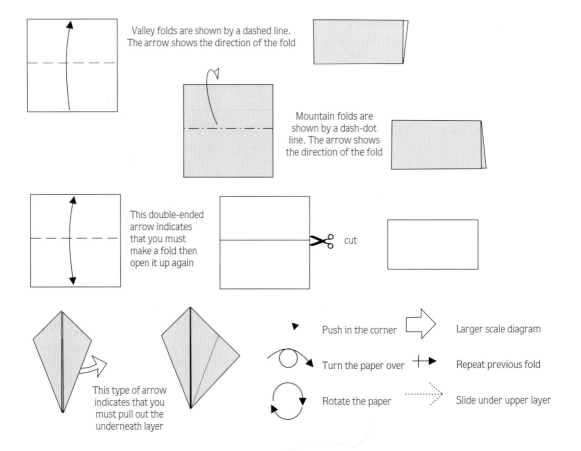

Valley folds are shown by a dashed line. The arrow shows the direction of the fold

Mountain folds are shown by a dash-dot line. The arrow shows the direction of the fold

This double-ended arrow indicates that you must make a fold then open it up again

cut

This type of arrow indicates that you must pull out the underneath layer

Push in the corner

Turn the paper over

Rotate the paper

Larger scale diagram

Repeat previous fold

Slide under upper layer

Folding papers

The projects in this book use sheets of folding papers on which are printed a series of 4cm and 5cm squares, divided by fine lines to help you cut them exactly square. Use a steel-edged ruler, a cutting mat and a craft knife to make the cuts.

International origami symbols have been used on all the folding sequence diagrams, and these are explained on page 4. Always look at where an arrow starts and where it goes, then fold the paper in that direction. The patterns are colour coded - a white square indicates that the back (or white side) of the paper is uppermost, a grey square indicates that the printed (or coloured) side of the paper is uppermost. Practise folds on large squares of scrap paper before starting a project.

Cutting papers

These sheets complement the folding sheets, and have eight-pointed stars printed on them. You can use these as a base for folding papers, you can layer them to create a fuller faux fold, or you can cut them into segments and use these to decorate projects or make mandala designs.

To create a faux fold, make mountain folds across opposite points of the cutting paper stars, then use scissors to make a series of cuts, from the edge of the valley (between each point) to just short of the center of the shape (most cutting papers have guide lines to help you). Layer these shapes together, using a spot of glue in the centre of each piece.

If you want a layered effect, and you do not want to use up your printed images, you can cut out more shapes from origami or other types of paper. The easiest way to create exactly the right shape is to use the matching rubber stamps that complement the cutting/folding papers.

Gluing

We suggest that you use a cocktail stick to apply tiny dots of PVA glue to the folded layers when gluing them together to form rosettes. Then, if one of the folds is not sitting correctly, you can usually open the rosette and reglue it. Alternatively, if you use a low-tack spray adhesive you will have no problems taking a rosette to pieces and reassembling it.

A high-tack spray adhesive is the best type of glue for layering sheets of paper together. Use a lino roller (brayer) to smooth down glued layers to ensure that all edges are stuck down firmly.

SAFETY RULES: Always use spray adhesives, paints and varnishes in a spray booth (a large cardboard box makes an excellent spray booth) and in a well ventilated area, such as the garage or near an open window. Do not use these products near children, animals, fish or food.

Stamping

For most of the projects we have used matching rubber stamps and dye ink pads to decorate plain papers with shapes and colours that complement those on the folding/cutting papers. We use dye ink as it dries rapidly and does not require embossing or a heat gun.

Sponging

An ordinary synthetic sponge cut in half or quarters gives excellent results. Dab the sponge a few times on to the ink pad and then on to the paper until the desired depth of colour and coverage is obtained.

Paper cutting

Photocopy the pattern and trim the paper to leave approximately 1.5cm all round the design. Place this pattern on the folding/coloured paper and staple them together outside the image area. You can make two paper cuts at the same time by stapling the pattern to two pieces of paper. Start cutting from the centre of the design and work outwards. When you have finished cutting, carefully peel the pattern from the paper cut, then use spray adhesive to mount the paper cut on to the project.

Paper architecture

We have used this technique, which involves papercutting and folding, to make pop-up insides to some card designs. Secure the piece of paper for the inside of the card on a cutting mat with masking tape. Photocopy the pattern, then secure this on top of the paper in the same way.

Starting in the centre of the design and working outwards, cut round all the solid lines, ending with the straight lines and the outside edges. Take care not to cut through the short fold lines which are denoted by broken lines.

Remove the pattern and carefully stroke a folding bone over the cut edges so that they lay nice and flat. Fold the architecture carefully along the fold lines and use double sided sticky tape to secure the architecture inside the folded card.

Paper burning

You need a pyrography iron fitted with an all-purpose point, rather than a fine point, for this technique. However, if you do not possess one of these, you can achieve reasonable results by drawing over the design with sepia ink.

Photocopy the pattern, then use graphite or tracing paper to transfer the design on to the paper to be burned. A graphite-paper tracing helps the iron run smoothly along the lines. Place the paper on to a piece of thick smooth cardboard (or mount board) and slowly follow the lines with the pyrography iron. Practise on a piece of scrap paper. Vary the speed of movement and note the different effects that can be achieved. Add texture/shading by dotting the iron in the relevant areas of the finished burn – make these dots close together in the dark areas, then gradually spread them out as you shade into the light areas.

SAFETY RULES: Never leave a pyrography iron unattended while it is switched on. Use the safety rest that comes with all pyrography irons. Do not lay them directly on to the work surface whilst switched on or when they are cooling down.

Stencil embossing

Embossing can greatly improve a plain design. Secure the embossing stencil on the right side of the paper with small pieces of low-tack sticky tape. Place the paper on a high-density foam mat (or a mouse mat) and run an embossing tool around the contours of the design. Keeping the stencil in position, turn the work over and place it back on the foam pad. You should be able to see the lines of the design on the back of the paper. Gently run a larger embossing tool along these lines so that you push the design to the right side of the paper. Carefully remove the stencil, and trim the paper to the finished size.

Fold sequence 1

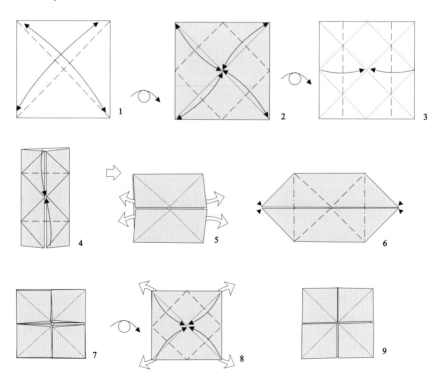

CHINESE CRANE

KIMONO CARD (see page 9)

Materials

A4 sheet of teal card
A4 sheet of terracotta paper
Folding papers
Matching full-fold rubber stamp
Library green dye ink
Spray adhesive and lino roller

Method

Use spray adhesive and the lino roller to bond the teal card to the back of the terracotta paper.

Use the rubber stamp and green ink to create a random pattern on the teal card.

Enlarge diagram 1 to create a full-size pattern for the Kimono shape, then cut this shape from the card/paper (all the solid lines are cutting lines).

Tip: Glue the full-size pattern on to thin card, then cut round the outlines to form a template that can be used many times.

Score along the dotted line, then fold the card so that the stamped side is on the outside.

Cut two 4cm square folding papers and glue one to each side of the folded card (see diagram 2).

Cut a 4 x 8cm rectangle (two 4cm squares) from the folding paper, place this face down on the full-size pattern for the Obi Bow (diagram 3a) and crease the folds. Fold the bow as diagram 3b, then pull the ends down to finish the bow as diagram 3c. Glue the back of the bow to the square of folding paper on the back of the card.

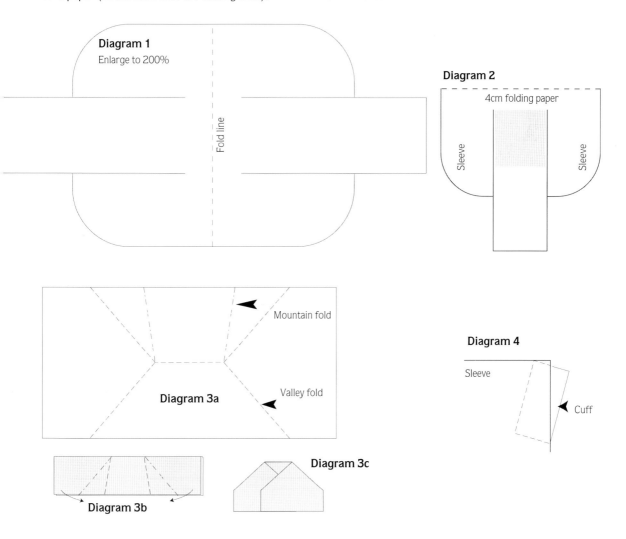

Diagram 1
Enlarge to 200%

Fold line

Diagram 2

4cm folding paper

Sleeve

Sleeve

Mountain fold

Valley fold

Diagram 3a

Diagram 3b

Diagram 3c

Diagram 4

Sleeve

Cuff

Diagram 5a

Mitre the corners

Teal card

Strong card

Diagram 5b

Teal card

Strong card

Diagram 6

Glue these pages to the inside covers

Cut a 4cm square folding paper, cut this in half, then fold each piece in half along its length. Fold each in half again across its width to form the cuff of the kimono sleeve. Glue the cuffs to the sleeves as shown in diagram 4, then cut along the top fold of each cuff to allow the card to be opened.

Fold a 5cm square folding paper to fold sequence 1, then glue the fold to the 4cm square on the front of the kimono to complete the card.

CRANE BIRD BOOK (see page 9)

Materials

Two 12.7cm squares of strong card
Two 14cm squares of teal card
One 7.5cm square of gold card
70.2 x 11.7cm strip of Sumi paper
Folding papers
Cutting papers
Matching full-fold rubber stamp
Library green dye ink
Spray adhesive

Method

Use the matching rubber stamp and green ink to create a random pattern on the squares of teal card.

Glue the pieces of strong card in the middle of the back of the teal cards, mitre the corners as shown in diagram 5a, then fold and glue the flaps as shown in diagram 5b.

Accordian-fold the strip of Sumi paper to form 11.7cm squares (diagram 6), then glue the first and last page in the middle of the backs of each cover.

Cut two 12cm squares (3 x 3, 4cm squares) from the folding paper, then glue these 'end papers' to the back of each cover to secure the first and last pages of the book.

Cut a 10cm square (2 x 2, 5cm squares) from the folding paper, then glue this to the middle of the front cover of the book.

Apply the wording to the outside edges of the 7.5cm square of gold paper, then glue this to the middle of the front cover. (We used a computer to print the wording on to the gold card, but you could use an alphabet stencil.)

Use four 4cm folding papers to make a rosette to fold sequence 2, then glue this in the middle of the gold square to complete the cover.

To decorate the book, you could make some 5cm rosettes to fold sequence 2 and glue these to the pages of the book.

Fold sequence 2

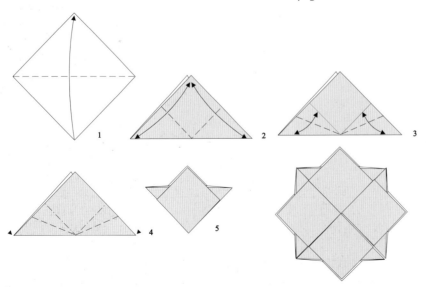

Diagram 7

CRANE BIRD PAPER CUT CARD (see page 9)

Materials

29 x 16cm piece of teal card
11.5 x 13cm piece of teal card
12.5 x 14cm piece of white paper
10.5 x 12cm piece of white paper
Folding paper
Cutting paper
Spray adhesive

Method

Fold the large piece of teal card in half to form a 14.5 x 16cm folded card.

Layer and glue together the small piece of white paper, the small piece of teal card and the large piece of white paper, equalising the borders all round.

Cut one of the star-shaped crane bird cutting papers in half, then fold the outer segments of each piece back to form corner shapes (see page 9). Glue these shapes to opposite corners of the layered card, then glue the layered card to the front of the folded teal card.

Use the full-size pattern (diagram 7) and part of the folding paper sheet to make a paper cut of the crane bird, then glue this to the front of the card.

Fold four 4cm squares of folding paper to fold sequence 3, glue these together to form the rosette, then glue the rosette to the front of the card as shown on page 9.

Fold sequence 3

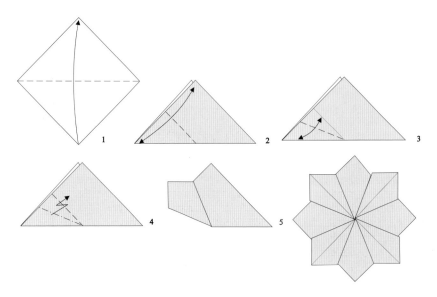

Fold sequence 4

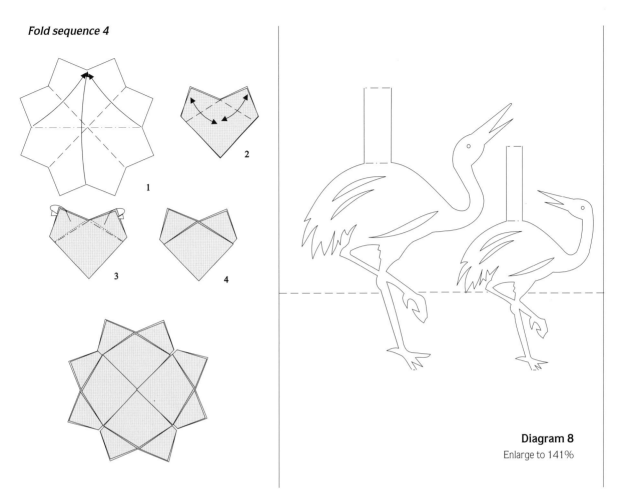

Diagram 8
Enlarge to 141%

PAPER ARCHITECTURE CARD (see page 9)

Materials

26 x 13.5cm sheet of teal card
Two 0.5 x 13.5cm strips of teal card
A4 sheet of white card
Matching full-fold rubber stamp
Library green dye ink
Sponge
Spray adhesive
Craft knife and cutting mat
Double-sided sticky tape

Method

Fold the teal card to form a rectangle 13 x 13.5cm, then, using the matching rubber stamp and green ink, create a random pattern on the front of the card.

Lightly sponge the white card with green ink. Enlarge diagram 8, then secure the pattern to the sponged card with masking tape. Referring to the instructions on page 5, cut along the solid lines of the pattern. Do not cut round the lowest toe of either bird as this is a fold line.

Remove the pattern, trim the card to 24.8 x 12cm, score along the fold lines, then carefully fold the card ensuring that you do not buckle the bird shapes.

Matching the fold lines, place the white card inside the teal card, then use double-sided sticky tape to secure two cards together.

Spray glue the two strips of teal card, 1cm apart, across the inside of the card; the top strip should be 5.8cm up from the bottom of the card.

Cut four star shapes from the cutting sheet, fold each to fold sequence 4, then use double-sided sticky tape to assemble the folds side by side to form the rosette. Secure the rosette to the top right-hand corner of the sponged card (see page 9).

Cut two more star shapes from the cutting paper, then glue these on top of each other in the front, top right-hand corner of the card. Place the top shape so that its points are midway between those of the bottom shape.

JAPANESE FAN

KIMONO FOLD CARD (see page 13)

Materials

28 x 19.4cm sheet of dark red card
21 x 18.4cm sheet of off-white card
10cm square of pale blue paper
Small piece of dark red paper
3cm square of gold paper
Compatible rubber stamps: Japanese fan and Japanese text
Purple dye ink
Gold ink
Folding papers
Double-sided sticky tape
Spray adhesive

Method

Fold the dark red card in half to form a 14 x 19.4cm rectangle.

Fold the off-white card as shown in diagram 9, then use double-sided sticky tape to secure the centre fold.

Use spray adhesive to secure the folded white card centrally on the front of the red card, then use Japanese text stamps and gold ink to create a design as shown on the photograph opposite.

Cut two 4cm folding papers, then fold these to stage 6 of fold sequence 5. Glue these, side by side, to the card as shown.

Use the fan rubber stamp and purple ink to create a random pattern on the pale blue paper.

Referring to diagram 10, fold and assemble the kimono. Glue this in the middle of the folded section of the card.

Retaining the edge strips, cut a 3cm square from the middle of a 4cm folding paper. Spray glue this, back to back, on the square of gold paper, then fold the Noshi as shown on diagram 12. Use the edge strips to make the Noshi band and strip. Finally, glue the Noshi to the top right-hand corner of the card.

Diagram 9

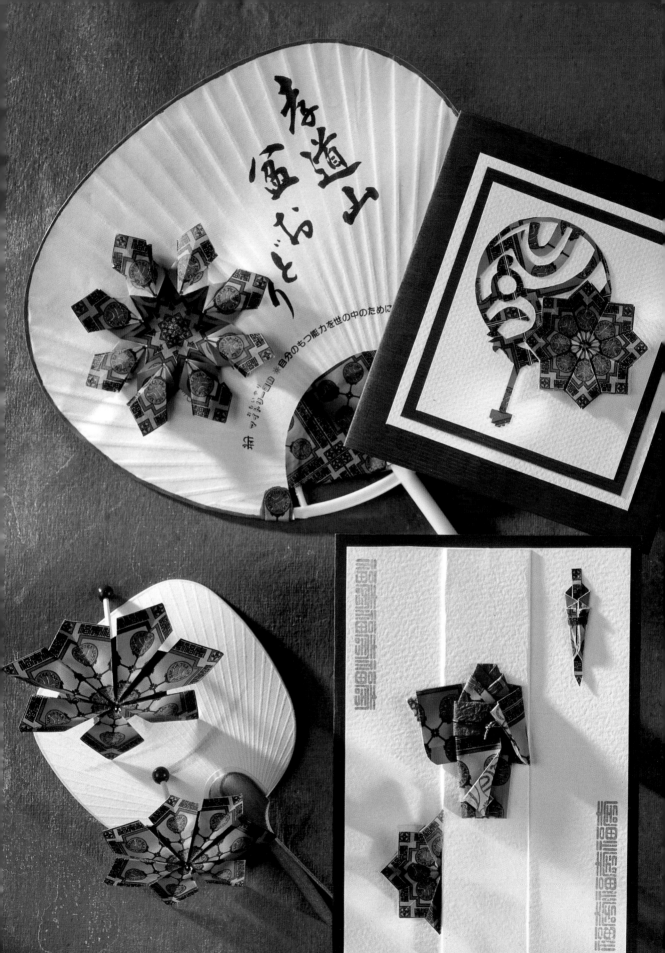

Diagram 10

Kimono: 6.8 x 7.4cm piece of folding paper
Sleeves: 6 x 7.5cm piece of folding paper
Under-kimono: 6.8 x 8cm piece of pale blue paper
Obi: 2.8 x 6.5cm piece of dark red paper
Neckcloth: 1.2 x 4cm piece of dark red paper
Cuffs: two, 1.6 x 4cm pieces of pale blue paper
Template for the neck: 0.5 x 4cm piece of thin card

Neckcloth

Template for neck

Kimono

6.4cm

6.8cm

Under-kimono

0.75cm

0.75cm

Under-kimono and Kimono
glued together with wrong
sides facing each other

6cm

Obi

If you have any Mizuhiki cord,
you could tie a short length
round the middle of the Obi

Cuffs

Glue the cuffs into the sleeves

Sleeves

FAN PAPER CUT CARD
(see page 13)

Materials

29.6 x 14cm sheet of dark red card
10.8cm square of dark red card
11.8 square of ivory paper
9.8cm square of ivory card
Matching full-fold stamp
Purple dye ink
Folding papers
Spray adhesive

Method

Fold the large sheet of red card to form a 14.8cm square, then use the stamp and purple ink to create a random pattern on the front.

Glue the large ivory square, the red square and the small ivory square on to the front of the folded red card, keeping the borders equal all round.

Referring to page 5, use the full-size pattern (diagram 11) to make a paper cut from a block of 5cm folding papers, then glue this to the card as shown on page 13.

Fold eight 4cm folding papers to fold sequence 5, then assemble them together to form a rosette. Glue this to the card as shown on page 13 to complete the project.

JAPANESE UCHIWA or FAN
(see page 13)

Materials

Japanese Uchiwa
Folding paper
Double-sided sticky tape

Method

Fold eight 5cm papers to fold sequence 6, then stick them together, side by side, on to a piece of double-sided tape. Remove the backing paper then secure the rosette on to the fan. If you want to use this fold to decorate a card, make the folds with 4cm papers.

Fold sequence 5

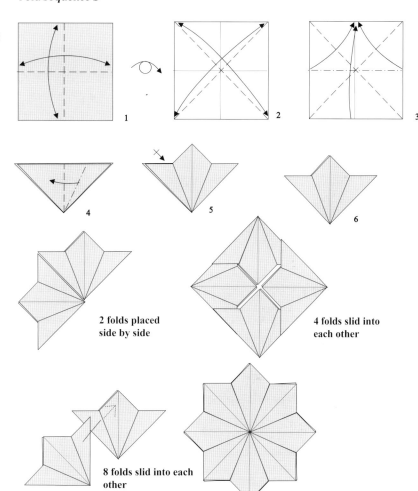

2 folds placed side by side

4 folds slid into each other

8 folds slid into each other

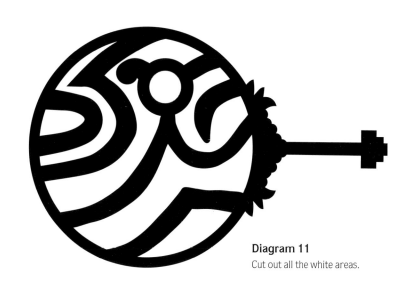

Diagram 11
Cut out all the white areas.

GOOD LUCK CHARM
(see page 12)

Diagram 12

Materials

Small pieces of strong card, white card, black crepe paper, pale yellow Washi paper
Lead curtain weight
Seven pale yellow wooden beads
4m of yellow Kusudama cord or gold thread
Four small brass cat bells
Brass curtain ring
Long darning needle
Folding paper
Spray adhesive

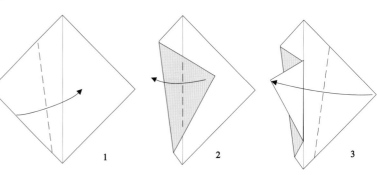

Method

Fold eight 4cm papers and four 5cm papers to fold sequence 5, then make three rosettes using four folds each. Only glue the overlapping side points so that the centres remain open.

Referring to diagram 13, make a folded doll as shown.

Cut a 1.2m length of cord, fold it in half then knot the loop on the brass

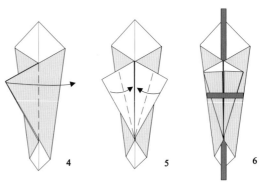

Fold sequence 6

Diagram 13

Enlarge these patterns to 200%

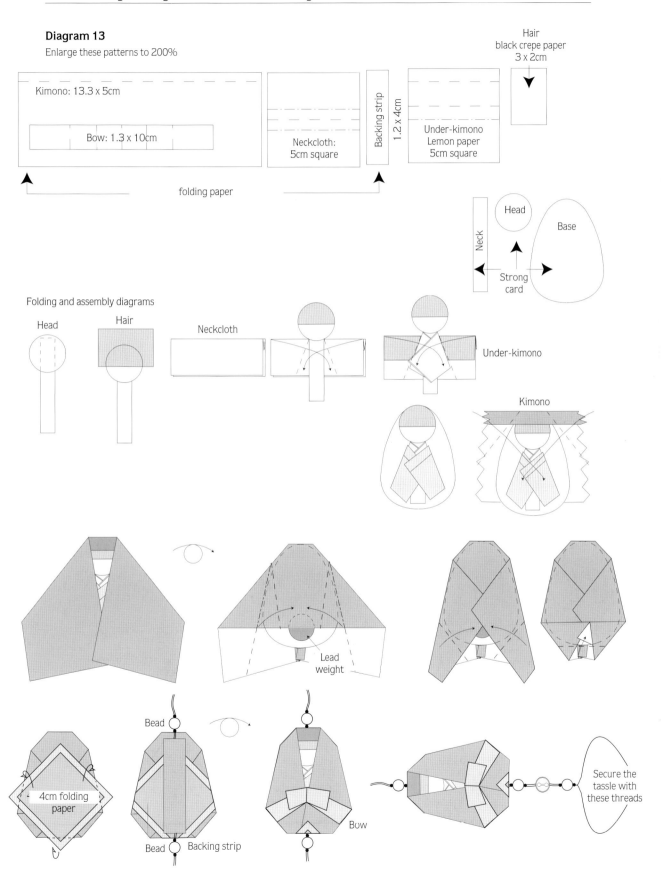

Hair
black crepe paper
3 x 2cm

Kimono: 13.3 x 5cm

Bow: 1.3 x 10cm

folding paper

Neckcloth:
5cm square

Backing strip

1.2 x 4cm

Under-kimono
Lemon paper
5cm square

Neck

Head

Base

Strong
card

Folding and assembly diagrams

Head

Hair

Neckcloth

Under-kimono

Kimono

Lead
weight

Bead

4cm folding
paper

Bead Backing strip

Bow

Secure the
tassle with
these threads

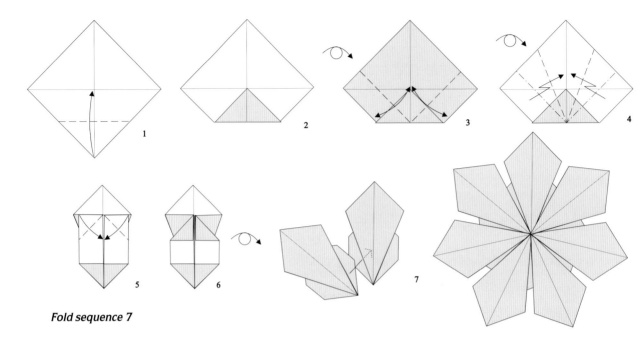

Fold sequence 7

ring. Tie a knot 8cm down from the ring, thread on a bead, then secure with a second knot.

Pierce a small hole in opposite points of one of the 4cm folds, pass the cords through the top hole, thread on a cat bell, then make a knot under the bell so that it sits in the centre of the fold.

Pass the cords through the bottom hole, make a knot, thread on a bead and secure this with a knot.

Repeat the procedure for the 5cm fold, then the second 4cm fold.

Tie a knot 5cm down from the last bead, thread on another bead and secure this with another knot. Glue the cords to the back of the folded doll and cover with the backing strip. Tie a knot under the doll, then thread and secure a bead, a catbell and the last bead 2.5cm apart.

Cut the rest of the cord into 10cm lengths and put one length aside. Use a piece of thread to tie a knot round the middle of the others. Lay the cords through the ends of the cords at the bottom of the hanging, wrap each end round the cords (over the securing thread) then tie the ends together with a small knot. Fold the tassels together, then wrap and secure the last 10cm length of cord round the fold to create the head of the tassel.

PARASOLS (not illustrated)

These parasols make lovely embellishments for cocktails. Use 5cm folding papers for large parasols and 4cm papers for smaller ones.

Materials

Small pieces of white card
Folding papers
Sate sticks
Blue wooden beads
Iridescent rocaille beads
Spray adhesive

Method

Photocopy diagram 14, cut the appropriate shape from thin card, glue a piece of folding paper to the underside, then trim off the excess. Curve the lining then glue the flap.

Fold seven folding papers to step 6 of fold sequence 7. Assemble the seven elements together, gluing just the lower surfaces. With the elements flat on the surface, you will end up with a gap between the first and last elements. Then, when you glue these together, the assembled fold becomes a shallow cone. Glue the fold on top of the lining.

Cut the sate stick to size, then push the blunt end into the wooden bead. Carefully push the pointed end through the parasol and secure with the rocaille bead to complete the parasol

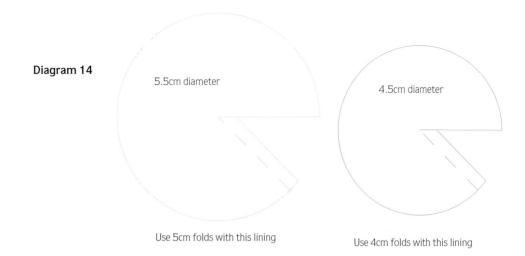

Diagram 14

5.5cm diameter

4.5cm diameter

Use 5cm folds with this lining

Use 4cm folds with this lining

CHINESE PEONY

PAPER ARCHITECTURE CARD (see page 21)

Materials

15 x 21cm piece of dark blue card
14 x 20cm piece of pale pink paper
Folding papers
Craft knife and cutting mat
Masking tape
Spray adhesive

Method

Make a full-size pattern from diagram 17, then secure this on top of the pale pink paper with masking tape. Referring to page 5, make a paper architecture of the design. The broken lines are for the folds.

Fold the blue card in half to form a 15 x 10.5cm rectangle, then open up again. Now cut a series of 14.1cm slits across the width of card: two slits on the front face of the card, 2 and 2.5cm in from the outer edge; and four slits on the back face, 2, 2.5, 3.5 and 4cm in from its outer edge.

Slide the pink architecture through the slits as shown on page 21, then glue the top and bottom edges to the blue card.

Use the pattern (diagram 16) to make two paper cuts from blocks of folding paper. Cut each paper cut exactly in half, then slide two halves under the slits on the inside back of the card as shown on page 21. Use spots of glue to secure the papercuts.

Glue the other two halves of the paper cuts on to the front of the card.

Backing board

11.5cm

Diagram 15

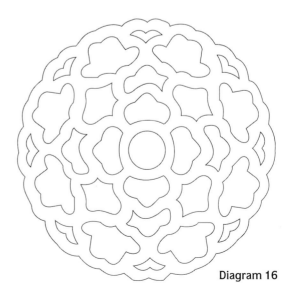

Diagram 16

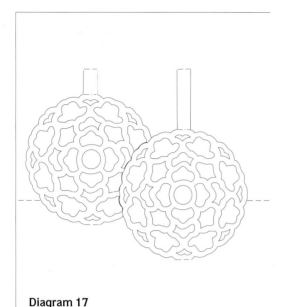

Diagram 17
Enlarge to 200%

Fold sequence 8

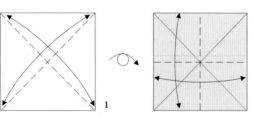

PEONY PICTURE (see page 21)

Material

23cm square box picture frame (purchased)
20cm square of 3mm foam board
Folding papers
Deep purple dye ink and sponge
Double-sided sticky tape
Spray adhesive
All-purpose glue

Method

Note: The measurement of the centre diamond is very important as it is sized exactly to accept the folds. You can use a larger frame but you must then allow for a wider border all round.

Lightly sponge the back of two folding paper sheets with dye ink, then cut and fold twenty-five 4cm papers to fold sequence 8.

Referring to diagram 15, make the pieces of the inner frame from foam board. Cut an 11.7cm square and cut this diagonally to form four triangles. Now cut four strips, 11.7cm long and 0.5cm wide, then mitre each end. Sponge all the foam board pieces, including the edges, and the backing board of the frame with deep purple dye ink.

Dry assemble the four triangles on the backing board as shown in diagram 15 and draw round the inside of the diamond shape. Draw faint pencil lines across the corners of this shape to help you place the folds. Secure the folds to the backing board with small pieces of double-sided sticky tape, spacing five folds along each diagonal line, then filling in the corners. When all folds have been secured, use tiny spots of glue to join the points of each fold.

Glue the four triangles round the set of folds, then glue the four strips to form the sides of the diamond. Mount and secure the panel to the frame.

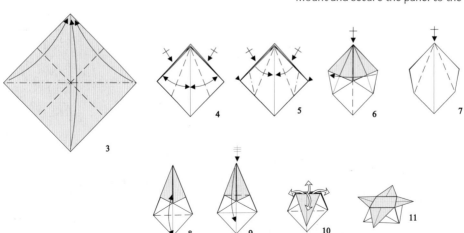

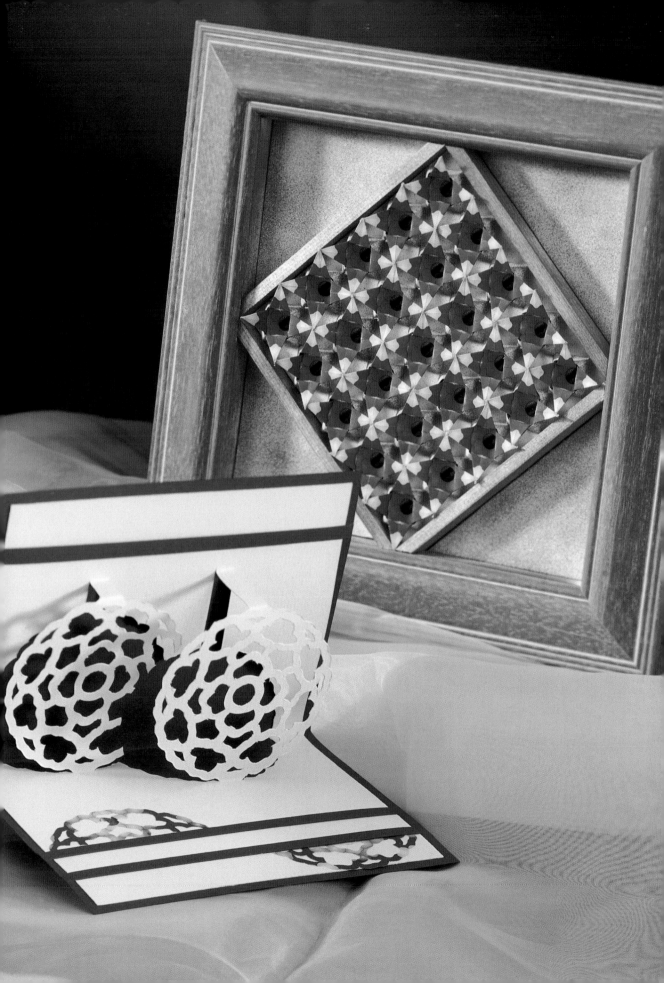

BLUE DRAGON

CHINESE STYLE BOOK (see page 29)

Materials

Ten 10 x 14.5cm pieces of thin white card
Two 10 x 14.5cm pieces of dark blue card
Small piece of gold paper
2m of 1cm wide ribbon
One folding paper
Two cutting papers
Matching full-fold stamp
Cobalt blue dye ink
High-tack spray adhesive
All-purpose glue
Narrow double-sided sticky tape

Method

Use the rubber stamp and cobalt blue dye to create a random pattern on one side of the two pieces of dark blue card.

Place strips of double-sided sticky tape across the top and bottom of six pieces of white card, 0.5cm in from the edge.

Lay all six pieces side by side leaving a 3mm gap between each sheet as shown in diagram 18.

Cut the ribbon in half, then mark the middle of each piece with a pin.

Remove the backing from the top strips of sticky tape, locate the centre of the ribbon between the third and fourth sheets, then lay the ribbon down on to the tape ensuring that the 3mm gaps between the pages are retained.

Secure the bottom length of ribbon in a similar way, but, at each end of the sheet, double the ribbon back on itself and take through the gap as shown on diagram 18.

Use spray adhesive to secure the remaining four pieces of white card of the middle four sheets, and the two pieces of blue card over the end sheets.

Cut five same-image squares from the cutting paper sheet. Cut one of these into its eight segments and use the other four to create the rosette shown in fold sequence 4. Glue this fold on to the piece of gold paper, then trim the edges of the gold paper to leave a 0.5cm border all round. Glue the eight segments under the gold paper, with their points between those of the rosette. Glue the completed rosette to the front cover of the book.

Cut a block of two 5cm folding papers then fold to fold sequence 9 to form a fan. Smear glue between the folds on the back of the fan to strengthen it. Tie a short length of gold ribbon round the bottom of the fan to complete it then mount this on one of the inside pages of the book.

Use your imagination to decorate the other pages of the book.

Fold sequence 9

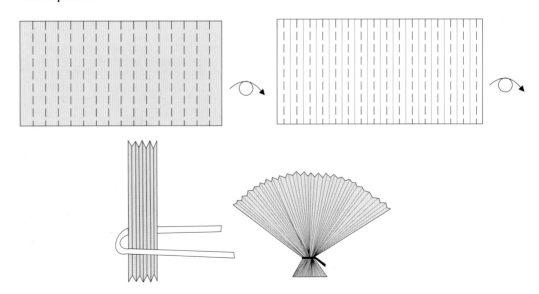

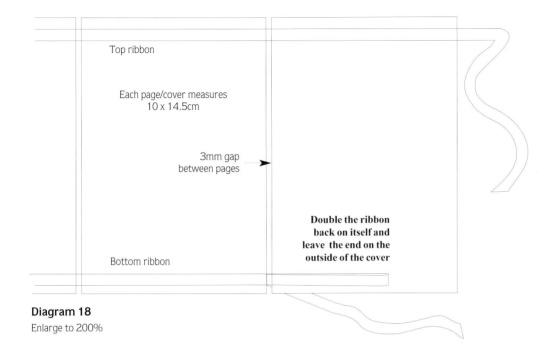

Top ribbon

Each page/cover measures
10 x 14.5cm

3mm gap
between pages

**Double the ribbon
back on itself and
leave the end on the
outside of the cover**

Bottom ribbon

Diagram 18
Enlarge to 200%

PAGODA LANTERN (see page 25)

We have given you two patterns for this project. One is a simple lattice design (diagram 20) without any embellishment, while the other has 'windows' covered with translucent paper and a paper fold. The materials listed below make one of the latter designs.

Materials
Two A4 sheets of dark blue card
9 x 27cm strip of Sumi paper (Japanese calligraphy paper)
All-purpose glue
Double-sided sticky tape
Folding paper

Method
Make a full size pattern from diagram 19, cut three of these shapes from the dark blue card, then score along the fold line of the tabs.

Cut three pieces of Sumi paper to the shape of the broken line on the pattern, then use all-purpose glue to secure these over the insides of the windows.

Stick strips of double-sided tape on the tabs then secure the three sides of the pagoda together, making sure that the adjacent points of the roof are both on the outside. Glue the tips of the roof together with all-purpose glue.

Cut sixteen 4cm folding papers in half. Use eight half-papers of the same design to make three rosettes

to fold sequence10, then use all-purpose glue to stick one rosette in the middle of each window.

Safety Note. If you want to use these pagodas as candle shades, place the nightlight or candle in a glass container tall enough to come above the flame. Do not leave lighted candles unattended or within the reach of children.

PAGODA CARD (see page 25)

Materials
Two A4 sheets of dark blue card
9cm square of Sumi paper
All-purpose glue
Folding paper

Method
Make full size patterns from diagram 21, cut the pagoda and three-sided frame shapes from the dark blue card and score the fold lines. Notice that the right-hand panel is slightly narrower than the left-hand one to allow the card to be folded correctly.

Cut the piece of Sumi paper to the shape of the broken line on the pattern, then use all-purpose glue to secure this on the back of the centre section of the three-sided frame.

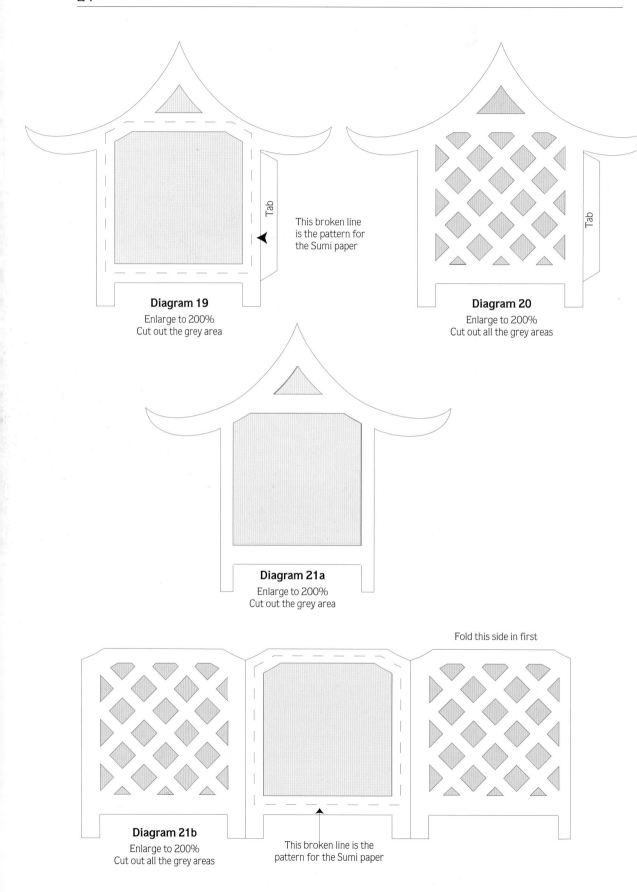

Diagram 19
Enlarge to 200%
Cut out the grey area

Tab

This broken line
is the pattern for
the Sumi paper

Diagram 20
Enlarge to 200%
Cut out all the grey areas

Tab

Diagram 21a
Enlarge to 200%
Cut out the grey area

Fold this side in first

Diagram 21b
Enlarge to 200%
Cut out all the grey areas

This broken line is the
pattern for the Sumi paper

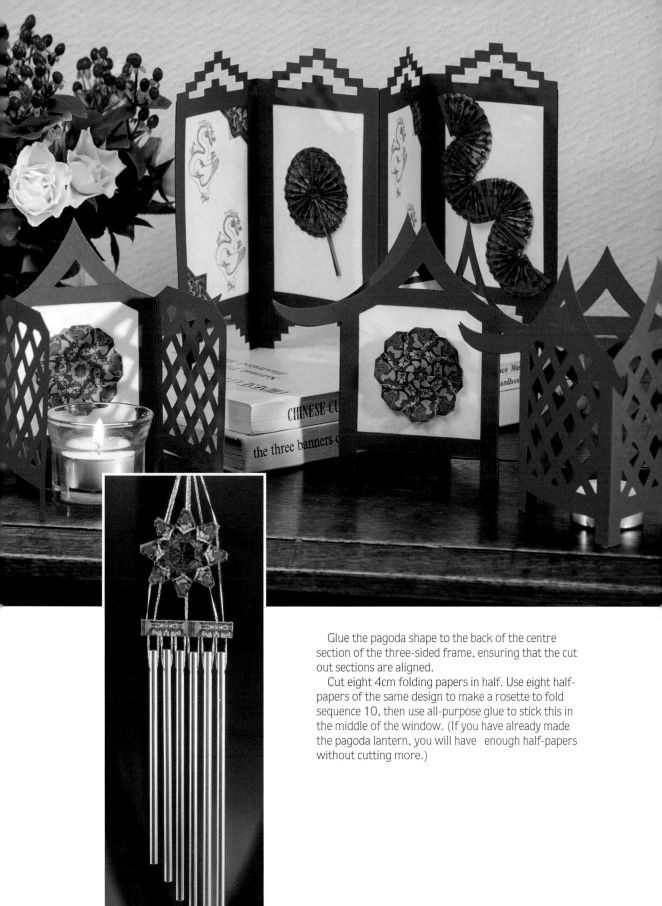

Glue the pagoda shape to the back of the centre section of the three-sided frame, ensuring that the cut out sections are aligned.

Cut eight 4cm folding papers in half. Use eight half-papers of the same design to make a rosette to fold sequence 10, then use all-purpose glue to stick this in the middle of the window. (If you have already made the pagoda lantern, you will have enough half-papers without cutting more.)

DRAGON CHIMES (see page 25)

Materials

Set of six 7mm wind chimes
3 x 8cm piece of 6mm foam board
2m gold thread
2cm diameter brass curtain ring
Tapestry needle
Strong sharp needle
All-purpose glue
Folding paper

Method

Cut two 1 x 17.5cm strips of foam board and two more from the sheet of folding paper, then glue a folding paper strip to one side of each foam strip. Use the strong sharp needle to pierce the sets of holes as shown in diagrams 22 a and b.

Cut three 20cm lengths of gold thread. Bring the threads together and knot the centre of them through the brass ring. Arrange the threads so they sit side-by-side, then thread them through the top section of foamboard as shown in diagram 22c. Adjust the threads so that the top section hangs horizontally, then secure the threads to the underside with all-purpose glue. Trim the ends of the threads to make a neat finish.

Thread a 1m length of thread on a tapestry needle, take the thread down through the end hole in the bottom sectionto leave a tail 1cm long. Glue this tail to the foam board and wait until the glue is completely dry. Now, working from the longest to the shortest chime, thread them on to the bottom section of foam board as shown in diagram 22d. Adjust the threads so that the tops of the chimes are aligned, then glue the thread to the foam board.

Glue the top section to the bottom section and set aside to dry.

Cut two 1.5 x 19cm strips of folding paper. Glue these to the sides of the chime support, ensuring that all overlaps are neat.

Use sixteen 4cm folding papers to make two rosettes to fold sequence 11. Glue these, back to back, across the top set of threads as shown in the photograph on page 25.

Fold sequence 10

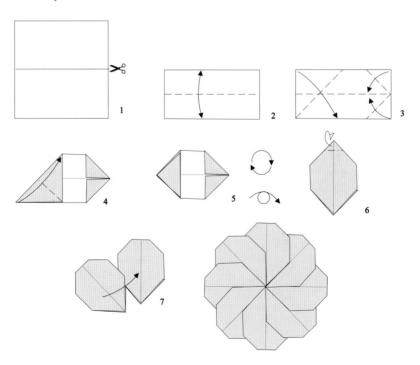

Diagram 22a

(top section of chime support)

Diagram 22b

(bottom section of chime support)

Positions for individual wind chime tubes

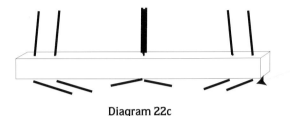

Diagram 22c

(Side view of top section showing the support threads)

Glue these two faces together

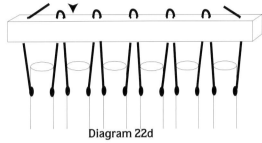

Diagram 22d

(side view of bottom section showing the support threads)

DRAGON SCREEN (see page 25)

Materials

Three A4 sheets of dark blue card
Four 9 x 13cm pieces of Sumi paper
All-purpose glue
Double-sided sticky tape
Compatible rubber stamp (dragon)
Cobalt blue dye ink
Folding paper
Cutting paper
Small piece of gold paper
Flat-back faux jewel

Method

Make full-size patterns from diagrams 23a and b, then cut two sets of screens (one without the tab) and four screen backs from dark blue card.

Cut the four pieces of Sumi paper to the shape of the broken line on the pattern, then use all-purpose glue to secure these on the back of the screens. Glue the screen backs to the back of the screens, ensuring that the cut out areas are aligned.

With the right side uppermost, apply a strip of double-sided sticky tape to the tab, then stick the other screen section to the tab. Score the fold lines then zigzag-fold the screen.

Use the rubber stamp and dye ink to decorate two of the windows then add segments from the cutting paper in the corners (see photograph on page 25).

Cut a 2.5 x 16cm strip of folding paper, then concertina fold this in a similar manner to that shown on fold sequence 9, but this time apply tiny spots of glue to the bottom of the folds. Cut two 5cm strips of gold paper and fold these in half lengthways. Glue one gold strip to each end of the top of the fold, form the circle and glue the two gold strips together to form the handle. Glue this on to the screen with all-purpose glue as shown on the photograph on page 25.

The festoon is made in a similar manner from four 2.5 x 16cm strips of folding paper. Each strip is formed into a semicircle then these are glued on to the screen as shown on the photograph.

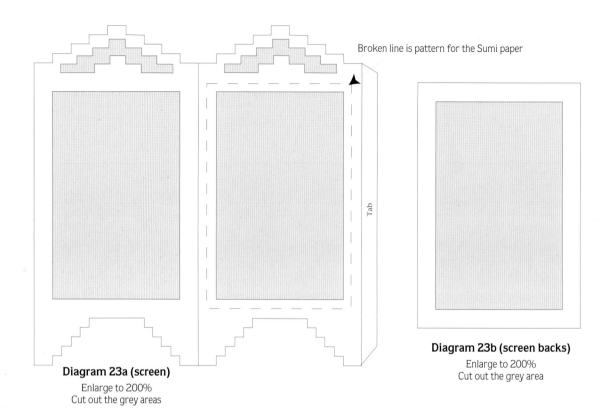

Broken line is pattern for the Sumi paper

Tab

Diagram 23a (screen)
Enlarge to 200%
Cut out the grey areas

Diagram 23b (screen backs)
Enlarge to 200%
Cut out the grey area

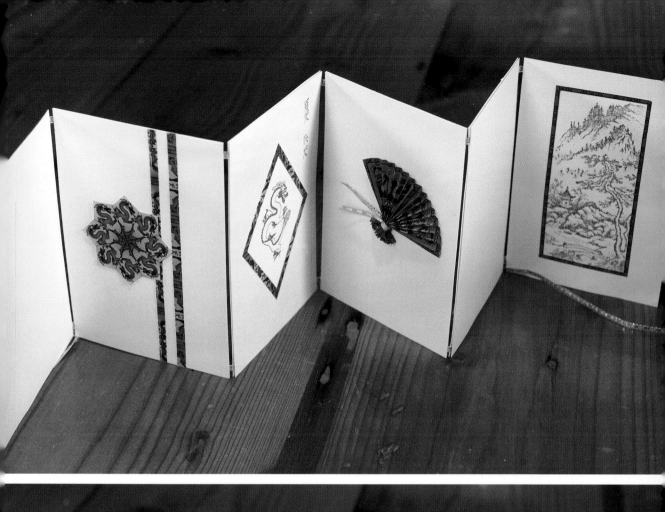
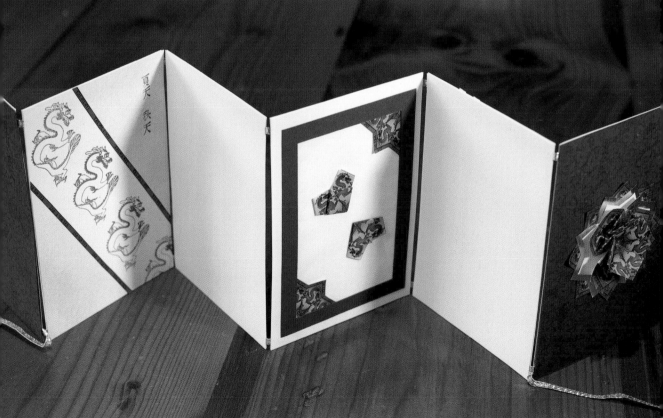

CHINESE LION DOG

RED, BLACK AND GOLD CARD (see page 33)

Materials

29 x 14.5cm piece of black card
12.5cm square of gold paper
12cm square of red paper
7.5cm square of gold metal sheet
7cm square of gold paper
Embossing stencil preferably with a Chinese theme
Embossing wheel and foam mat
Spray adhesive
Double-sided sticky tape
Folding paper

Method

Fold the black card in half to form a 14.5cm square. Glue the 12.5cm square of gold paper in the middle of the front face of the card.

Referring to page 6, emboss the border design around the edge of the red paper, then glue this on to the gold paper.

Working on the foam mat, use the embossing wheel to create a border around the edge of the square of metal. Use double-sided sticky tape to assemble this on top of the red paper, then the small square of gold paper on to the metal.

Cut eight 4cm folding papers in half, then use eight half-papers of the same design to make a rosette to fold sequence 12. Glue the rosette in the middle of the gold paper to complete the project.

Fold sequence 11

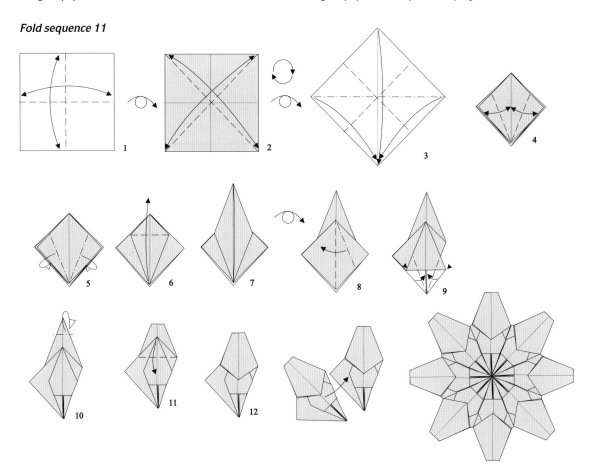

Diagram 24
Enlarge to 200%

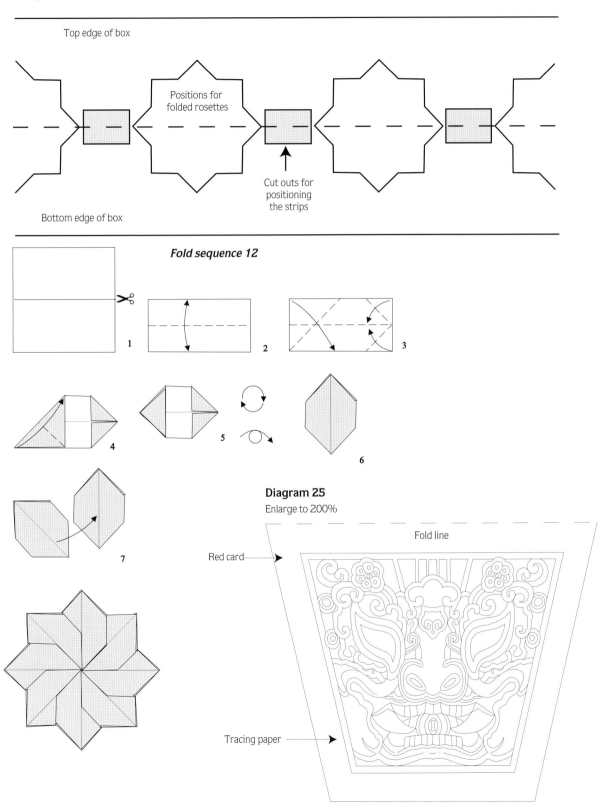

Top edge of box

Positions for
folded rosettes

Cut outs for
positioning
the strips

Bottom edge of box

Fold sequence 12

1

2

3

4

5

6

7

Diagram 25
Enlarge to 200%

Fold line

Red card

Tracing paper

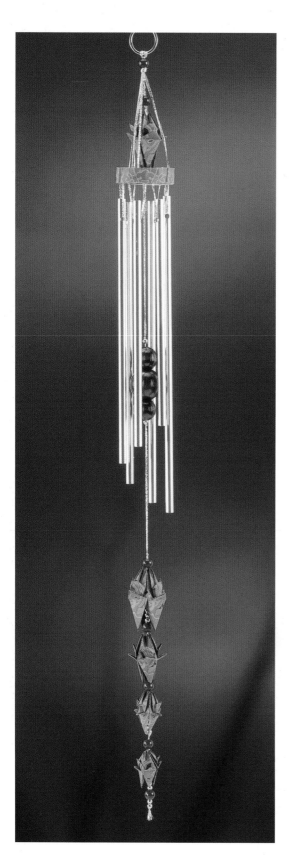

CHINESE LION DOG CARD (see page 33)

Materials

A4 sheet of red card
A4 sheet of 90gsm tracing paper or parchment paper
Gold gel pen
Gold ink
Paintbrush
Spray adhesive
Folding paper

Method

Enlarge diagram 25 to create a full-size pattern.
Fold the red paper in half, align the fold line along the fold, then cut the red card to shape.

Use the gold pen to trace the lion dog design on to tracing paper then use the gold ink and a paintbrush to fill in the design as shown in the photograph on page 33. Cut round the outer edge and spray glue the tracing paper on to the front of the card.

Cut eight 4cm folding papers diagonally in half, then sort them into two sets of the same design. Use each set to make two rosettes to fold sequence 13, then glue one at the top left-hand corner of the card and one at the bottom right-hand corner.

CHINESE SCROLL (see page 33)

Materials

22 x 21cm piece of red card
19 x 9cm piece of gold paper
16 x 7 piece of Sumi paper
A4 sheet of white paper
0.5 x 8cm strip 3mm foam board
9cm length of 6mm diameter wooden dowel
12cm gold thread
Gold ink
Folding paper
Spray adhesive
All-purpose glue
Double-sided sticky tape

Method

Dip the ends of the dowel and the strip of foam board in gold ink and set aside to dry.

Fold the red card in half to form an 11 x 21cm folded card.

Use spray glue to secure the piece of gold paper in the middle of the front of the red card.

Cut the full 2 x 4 block of 5cm folding papers, then trim 1cm off of both long edges and one short edge

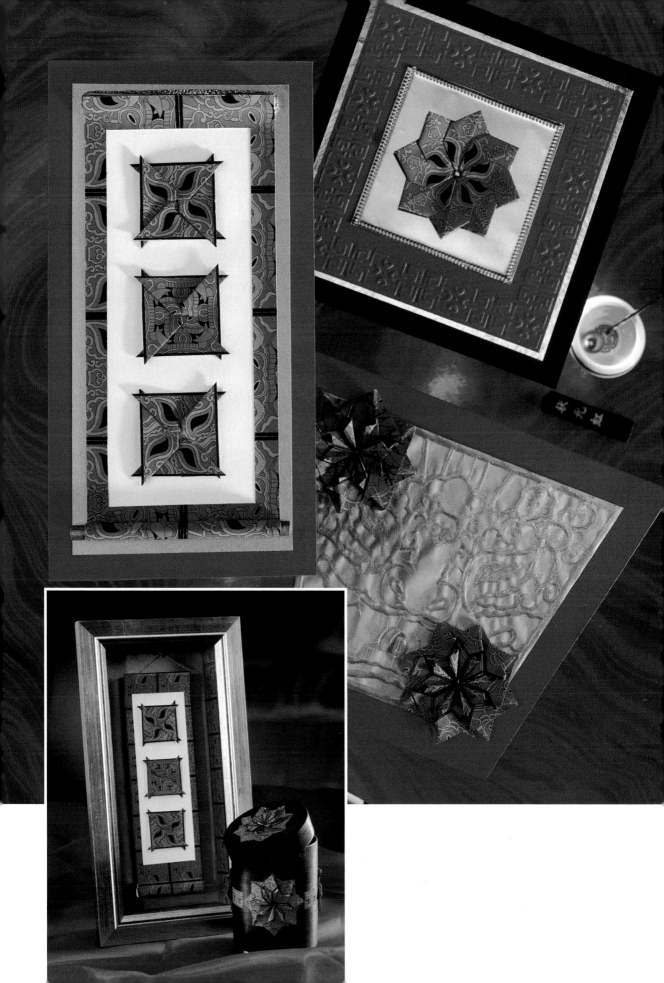

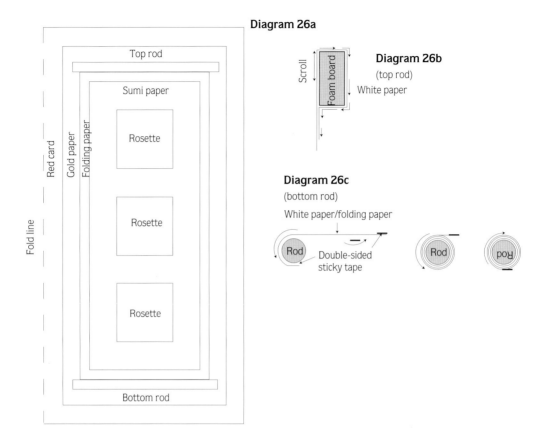

Diagram 26a

Top rod

Sumi paper

Rosette

Rosette

Rosette

Bottom rod

Red card

Gold paper

Folding paper

Fold line

Scroll

Foam board

Diagram 26b

(top rod)

White paper

Diagram 26c

(bottom rod)

White paper/folding paper

Rod

Double-sided
sticky tape

Rod

poᴚ

to form an 8 x 19cm rectangle (the trimmed short edge will be the top of the scroll).

Cut a 6 x 15.2cm aperture in the rectangle, starting 1.4cm down from the top edge.

Use all-purpose glue to secure the sheet of Sumi paper behind the aperture, then use spray glue to secure the whole block to the sheet of white paper. Trim the white paper flush with the long sides, but leave a 2.5cm border at the top and bottom of the folding paper - the assembled sheet should now measure 8 x 24cm.

Referring to diagram 26c, place a narrow strip of double-sided sticky tape across the scroll so that its top edge is 1cm down from the aperture in the folding paper. Turn the scroll over and place another narrow strip of tape across the bottom edge of the white paper. Place the dowel centrally on the bottom strip of tape. Roll the scroll round the dowel until you reach the strip of tape on the front then reverse the roll on to this strip.

Referring to diagram 26b, smear all-purpose glue across the top of the rectangle, lay the strip of foam board so that its top edge aligns with the top of the folding paper, then fold the white border over the foam board and down on to the back of the scroll. Use gold ink to paint the top white edge of the scroll.

Place the gold thread along the top of the scroll and secure the ends under the foam board.

Use spray adhesive to secure the scroll in the middle of the gold paper on the card.

Cut eight 4cm folding papers in half, then make three rosettes to fold sequence 14, using four half-papers of the same design for each. Use all-purpose glue to mount these rosettes on to the scroll as shown in the photograph on page 33.

Note: the large scroll shown in the photograph is made in much the same way as above but to a larger scale. The aperture measures 6.2 x 19.2cm, both rods are made from wooden dowel, and the rosettes are folded from 5cm papers.

Fold sequence 13

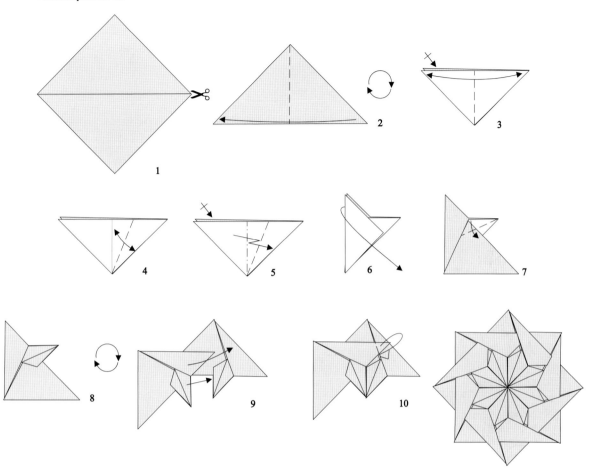

Fold sequence 14

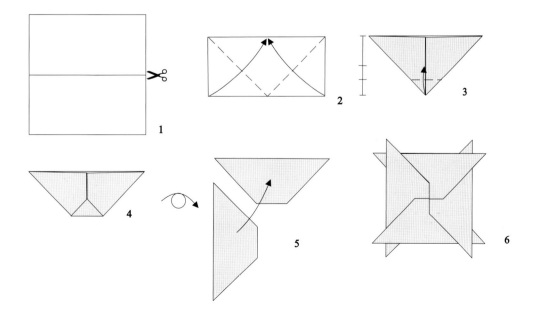

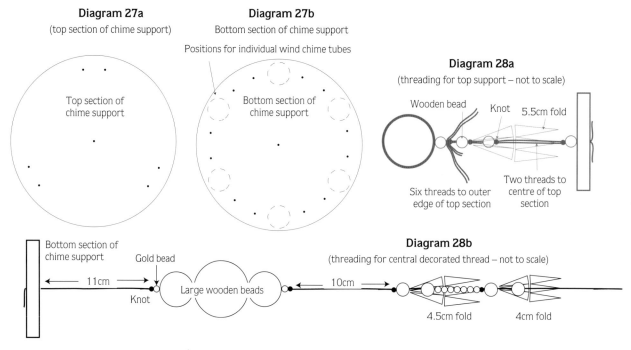

Diagram 27a
(top section of chime support)

Top section of chime support

Diagram 27b
Bottom section of chime support

Positions for individual wind chime tubes

Bottom section of chime support

Diagram 28a
(threading for top support – not to scale)

Wooden bead Knot 5.5cm fold

Six threads to outer edge of top section

Two threads to centre of top section

Bottom section of chime support

Gold bead

11cm

Knot Large wooden beads

Diagram 28b
(threading for central decorated thread – not to scale)

10cm

4.5cm fold 4cm fold

TEA CADDY (see page 33)

Materials

9.5cm diameter wooden box
Four 1.5cm diameter wooden beads (optional)
Black acrylic ink
Sponge brush
Gold ink (optional)
Two folding papers
All-purpose glue

Method

Paint the outside of the box and its lid with black acrylic ink. Paint the insides of the box, its lid and the wooden beads with gold. Set aside to dry.

Use all-purpose glue to secure the bead feet to the bottom of the box.

Enlarge diagram 24 to create a full-size positioning pattern, cut out the grey rectangular apertures, then tape the pattern around the box.

Cut three 2.5 x 1.8cm strips from the folding paper, then glue these to the box through the apertures in the positioning pattern.

Cut sixteen 5cm folding papers diagonally in half and sort them into two sets of the same side. Use sets of eight half-papers to make four rosettes to fold sequence 13. Glue one of these rosettes to the top of the lid and the other three around the sides of the box between the folding paper 'ribbon'.

CHINESE CHIMES (see page 32)

Materials

Set of six 7mm wind chimes
12 x 7cm piece of 6mm foam board
3.5m of 2mm wide gold thread
Tapestry needle
2cm diameter brass ring
Strong sharp needle
All-purpose glue
Twelve red wooden beads
Twenty-five gold beads
Two 1.5cm diameter wooden beads
One 2.3cm diameter wooden bead
Folding paper
Cutting paper

Method

This project uses five different sizes of folding papers: 5, 4.5, 4, 3.5 and 3cm square. Cut four of each size, then, working to fold sequence 15, create three-dimensional shapes.

Cut two 4.5cm diameter circles from the foam board and two more from the cutting paper. Glue the paper circles on to the foam board ones, then use a strong needle to pierce holes as shown in diagrams 27a and 27b.

Cut four 40cm lengths of gold thread, bring the four lengths together, fold them in half and loop them through the brass ring.

Pass all the threads through a red bead, push the bead up to the ring and tie a knot under the bead (see diagram 28a).

Fold sequence 15

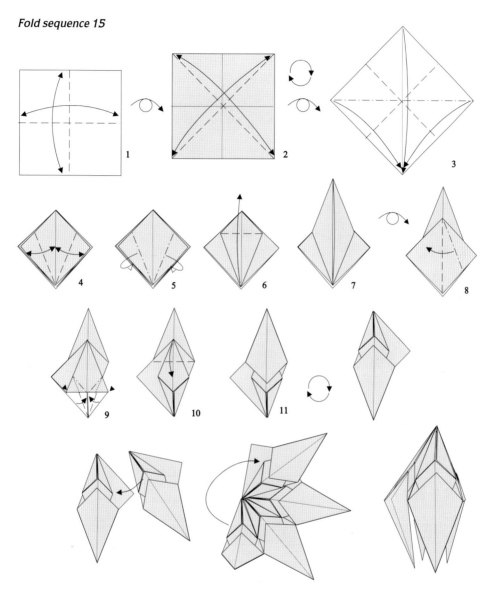

Separate the threads and pass two through a second red bead. Leave a 1.5cm gap between this bead and the one above, then tie a knot under the bead. Pass the threads through the top of the 5cm fold and another red bead, then tie a knot to hold the bead and fold in place. Leave a gap of approximately 3cm, make another knot, thread on a red bead, pass the threads through the centre hole of the top section of the chime support, then glue the ends of the threads to the underside of the foam board.

Take the remaining six threads through the other holes in the top section, adjust the foam board so that it hangs horizontally, then glue the ends of the threads on the underside of the foam board.

Cut a 50cm length of thread, pass this through the centre hole in the bottom section of the chime support and glue the tail to the foam board. Now, thread the beads and folds on to this thread as shown in diagram 28b (the top fold is the 4.5cm one, and this is followed by decreasing sizes of fold). The gold beads act as spacers, so you will require fewer of them as the folds get smaller. Finish this central decoration with a red bead, two gold ones and a knot. Trim off the excess thread.

Use the rest of the thread to assemble the chimes round the bottom section of the support in a similar manner to those described on page 26. Use all-purpose glue to secure the top section to the bottom section, then leave this to dry.

Finally, cut a 15 x 1.2cm strip of folding paper then glue this around the support to complete the project.

CELTIC EAGLE AND KNOT

COLUZZLE CARD (see page 41)

Materials

13 x26cm piece of dark blue card
6.5 x 12.5cm piece of dark blue card
12.5cm square of pale blue card
Coluzzle knife, circle template and cutting mat
Matching full-fold rubber stamp
Cobalt blue dye ink
Masking tape
Spray adhesive
Two cutting papers

Method

Place the pale blue paper on the cutting mat, then use pieces of masking tape to secure the circle template to the middle of the paper. Working on just the right-hand side of the template and starting with the small diameter, cut around the concentric circles. Hold the knife vertically and keep the blade against the edge of the template. Trim round the edges of the template, remove the template, then carefully lift and fold back the first, third and fifth semicircles.

Alternatively, enlarge diagram 29 to make a full-size pattern, then use a scalpel to cut round the concentric semicircles as shown.

Place the cut out face up on to a piece of scrap paper then use the rubber stamp and cobalt blue ink to create a random pattern all over it.

Use a pair of scissors to round the corner on the right-hand side of the paper and also those on the right-hand side of the dark blue card.

Turn the pale blue paper over, mask the left-hand semicircles, apply spray glue then mount the cut out on the front of the dark blue card.

Use spray glue to mount the small piece of dark blue card to the left-hand side of the cut out, leaving the semicircles free.

Use four identical shapes from the cutting sheet to create a rosette to fold sequence 16, then glue the fold in the middle of the blue card as shown in the photograph on page 41

Diagram 29
Enlarge to 200%

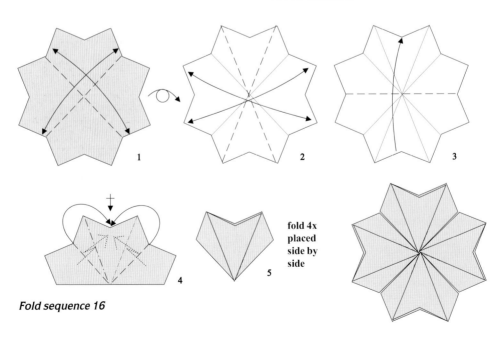

1

2

3

4

5

fold 4x
placed
side by
side

Fold sequence 16

Diagram 30a

Enlarge to 200%

Fold line

Diagram 30b

(full size)

Fold sequence 17

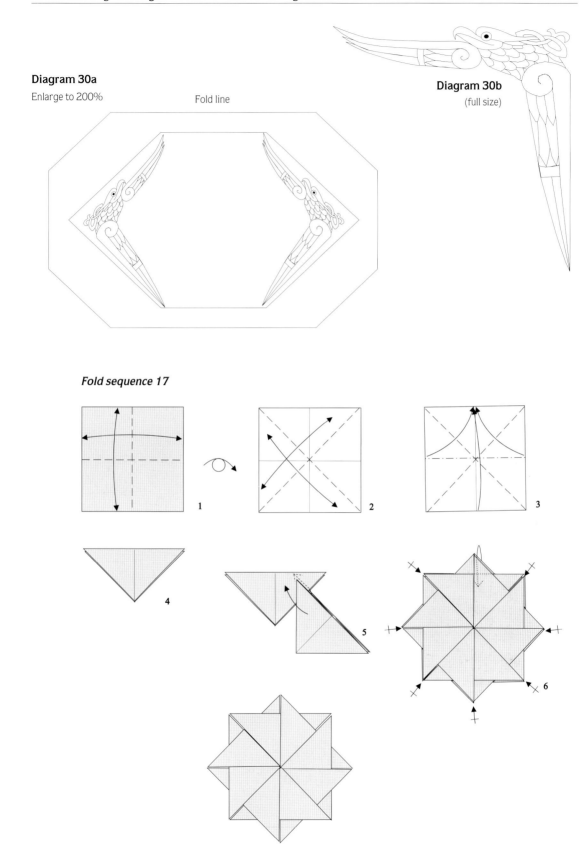

PAPER BURN CARD (see page 41)

Materials

Pyrography iron
Graphite paper
Piece of smooth thick board
22.6 x 18cm piece of dark blue paper
15.8 x 9.3cm piece of pale blue paper
Spray adhesive
Folding paper

Method

Enlarge diagram 30a to make a full-size pattern. Fold the dark blue paper in half to form a 11.3 x 18cm rectangle, then cut the corners to the outer edges of the pattern.

Cut the corners of the pale blue paper to the inner shape on diagram30a.

Trace the eagle design, diagram 30b, transfer it on to the top and bottom of the pale blue paper, then use the pyrography iron to make the paper burn as described on page 6. If you do not possess such an iron then use a sepia pen to drawn the design. Use spray adhesive to mount the paper burn on to the dark blue paper.

Use eight 4cm folding papers to make the rosette to fold sequence 17, then glue this in the middle of the card to complete the project.

PAPER ARCHITECTURE CARD (see page 41)

Materials

A5 sheet of dark blue paper
A4 sheet of dark blue paper
A4 sheet of pale blue paper
Folding paper
Cutting paper
Craft knife and cutting mat
Spray adhesive

Method

Use spray adhesive to stick the A4 sheets of paper together and place them with the pale blue side uppermost on a cutting mat.

Enlarge diagram 31 to make a full-size pattern, secure the pattern to the pale blue paper and cut around all the solid lines on the pattern (see page 5).

Remove the pattern. Turn the cut out over (dark blue side uppermost) and stick strips to the long edges of the rectangles at each end of the cut out. Make a mountain fold in the middle of the cut out (the pale blue side is the top side), and valley folds where the design meets the rectangles at each end. Stick

Diagram 31
Enlarge to 141%

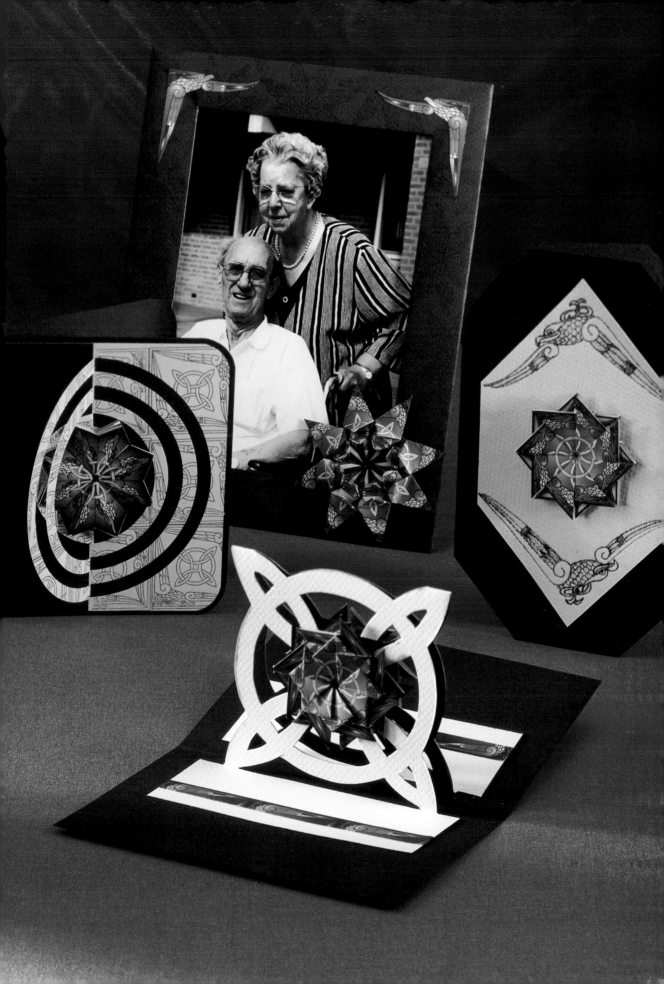

Fold sequence 18

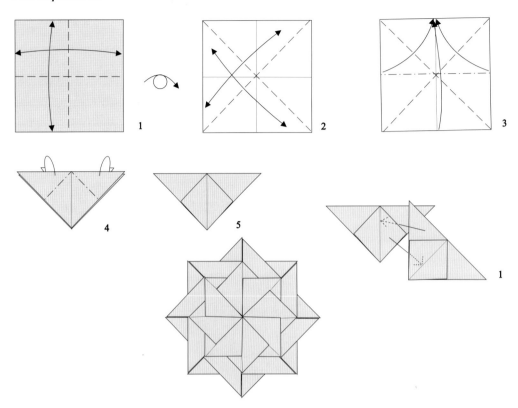

strips of double-sided sticky tape across the long edges of both rectangles.

Fold the A5 sheet of dark blue paper in half then open up the fold again. Draw a feint line across the card, 1cm up from the fold line, remove the backing tape from the strips of tape on the lower rectangle, align the edge of the fold to the drawn line then press to secure. Remove backing from the strips of tape on the top of the fold, fold the blue card over and press to secure the join.

Cut sixteen 4cm folding papers and make two rosettes to fold sequence 18. Glue one rosette to each side of the folded pale blue cut out.

Cut two 1cm wide strips of folding paper to fit across the rectangles on the pale blue paper as shown in the photograph.

Finally cut two shapes from the cutting paper and stick these on to the front of the card.

PHOTOGRAPH FRAME (see page 41)

Materials

Cardboard photograph frame (17 x 22cm)
A4 sheet of Dark blue paper
Matching full-fold rubber stamp
Cobalt blue dye ink
All-purpose glue
Folding paper

Method

Carefully remove the back from the frame and sponge its edges and outer face with cobalt blue ink.

Use the rubber stamp and cobalt blue ink to create a random pattern on the dark blue paper, then use all-purpose glue to cover the frame.

Use the all-purpose glue to stick the back on to the frame, ensuring that you leave the top opening free to accept the photograph. Cut three eagles from a 5cm folding paper then glue these to the top corners and the bottom left-hand corner.

Cut eight 4cm folding papers, make a rosette to fold sequence 19 and glue this to the bottom right-hand corner of the frame to complete the project.

CELTIC DOGS HEAD AND KNOT

BLUE AND GOLD EMBOSSED CARD
(see page 45)

Materials

28.4 x 14.2cm piece of blue paper
10.8cm square of blue paper
12.2cm square of lavender paper
7.8cm square of lavender paper
11.8 cm square of gold paper
7.2cm square of gold paper
Embossing stencil
Spray adhesive
Matching full-fold rubber stamp
Cobalt blue dye ink
Folding paper

Method

Fold the large piece of blue paper in half to form a 14.2cm square.

Referring to the photograph on page 45, use the rubber stamp and cobalt blue ink to create a border design around the edges of the front of the folded card, and in the middle of each side of the 10.8cm square of blue paper.

Referring to the instructions on page 6, use the embossing stencil to emboss a design in the middle of the small square of gold paper.

Use spray adhesive to mount the large square of lavender paper, the large square of gold paper, the small square of blue paper, the small square of lavender paper and the embossed square of gold paper in layers on the front of the card. Equalise the borders between each layer.

Cut four 4cm folding papers in half, then fold the eight half-papers to create the rosette shown in fold sequence 20. Glue the rosette in the middle of the embossed gold square to complete the project.

PAPER BURNING CARD (see page 45)

Materials

Pyrography iron
Thick piece of smooth cardboard
Graphite paper
Scissors or circle cutter
29.4 x 14.7cm piece of blue paper
11.5cm diameter circle of blue paper
5.7cm diameter circle of blue paper
12.7cm diameter circle of ivory paper
9.8cm diameter circle of ivory paper
Matching full-fold rubber stamp
Cobalt blue dye ink pad
Spray adhesive
Folding paper

Method

Fold the large sheet of the blue paper in half to form a 14.7cm. square. If required, use scissors to round off the corners as shown on page 45.

Use the rubber stamp and cobalt blue ink to create a random pattern on the front of the card.

Enlarge diagram 32 to make a full-size pattern and use the graphite paper to transfer the design on to the small circle of ivory paper. Then, referring to page 6, burn the pattern on to the paper.

Use four 4cm folding papers to create a rosette to fold sequence 10.

Use spray adhesive to layer the large ivory circle, the large blue circle, the finished paper burn circle and the small blue circle on the front of the card, ensuring that the borders are equal all round.

Glue the rosette in the middle of the small blue circle to complete the project.

Fold sequence 19
Start from stage 11 of fold sequence 15

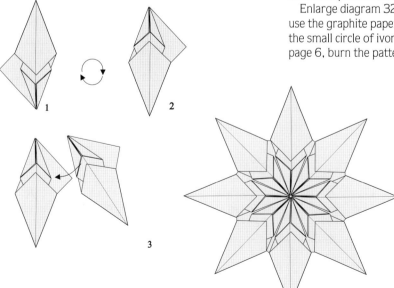

Diagram 32
Enlarge to 200%

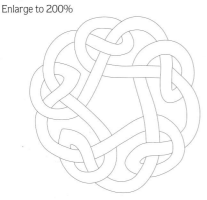

Diagram 33
Enlarge to 141%

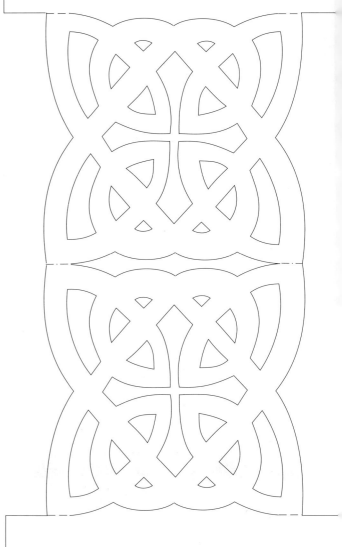

PAPER ARCHITECTURE CARD (see page 45)

Materials

21 x 14.8cm piece of blue paper
A4 sheet of lavender paper
Matching full-fold rubber stamp
Cobalt blue dye ink
Gold ink
Sponge
Folding papers
Cutting papers
Double-sided sticky tape
Spray adhesive

Method

Fold the blue paper in half to form a 14.8 x
10.5cm folded card

Use the full-fold stamp and cobalt blue ink to
create a random pattern all over the inside faces
of the card.

Sponge the sheet of lavender paper with gold
ink and set it aside until it is completely dry.

Enlarge diagram 33 to make a full-size
pattern, then, referring to the instructions on
page 6, cut the paper architecture design from
the sponged lavender paper (the sponged side is
the right side).

Make a mountain fold through the centre line
of the architecture, and valley folds at each end.
With the architecture folded flat, place strips of
double-sided sticky tape along the top and
bottom edges of the unsponged rectangles.
Turn the folded architecture over and apply
strips of tape to the other rectangle.

Open out the folded card so that the stamped
face is uppermost. Remove the protective

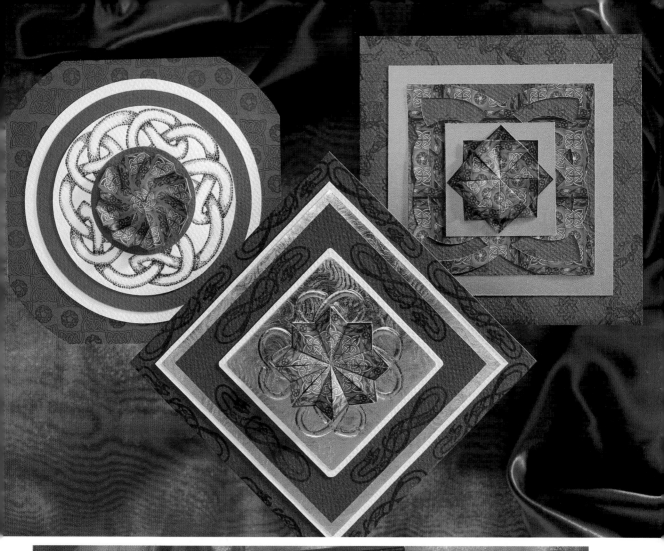
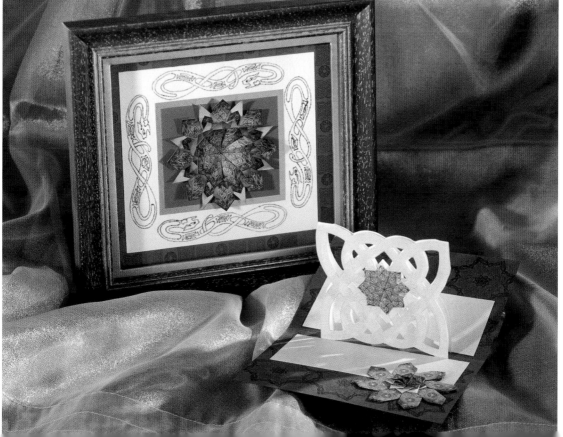

Fold sequence 20

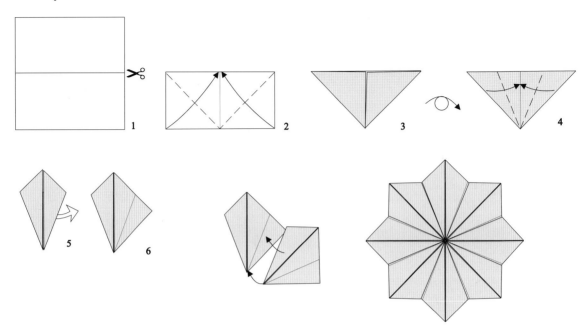

backing from the strips of tape on one side of the folded achitecture, then stick the folded architecture on the opened up card so that its valley folds are 0.5cm out from the fold line of the card. Remove the the protective backing from the rest of the sticky tape and carefully close the card so that the architecture sticks to the inside front of the card.

Use eight 4cm folding papers to create a rosette to fold sequence 21, then glue the rosette to the bottom right hand corner of the inside of the card as shown in the photograph on page 45.

Cut two patterned star shapes from the cutting paper and stick one on each side of the architecture (see photograph).

BLUE AND GOLD PAPER CUT CARD
(see page 45)

Materials

29.6 x 14.8cm piece of blue paper
9.8cm square of blue paper
11.8cm square of gold paper
5.8cm square of gold paper
Matching full fold rubber stamp
Cobalt blue dye ink
Spray adhesive
Folding papers

Method

Fold the large sheet of blue paper in half to form a 14.8cm square folded card. Use the rubber stamp and cobalt blue ink to create a random pattern on the front of the folded card and the square of blue paper.

Enlarge diagram 34 to make a full-size pattern, then, referring to the instructions on page 5, make a paper cut out of a piece of folding paper.

Use spray adhesive to layer the large square of gold paper, the stamped square of blue paper, the paper cut and the small square of gold paper in the middle of the front of the folded card.

Use four 4cm folding papers to make a rosette to fold sequence 20, then, finally, glue the rosette in the middle of the small square of goldpaper.

Diagram 35
Enlarge to 200%

Diagram 34
Enlarge to 200%

Diagram 39

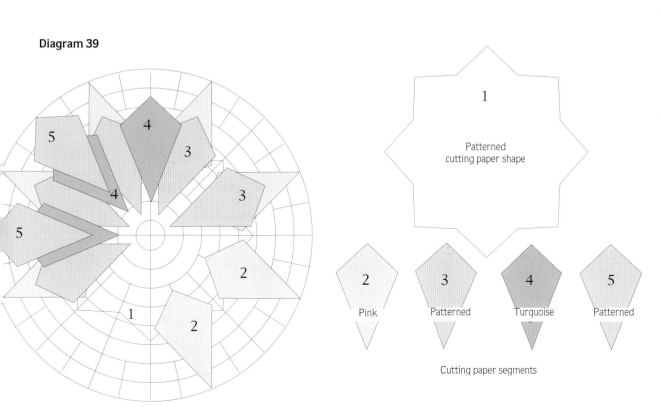

1
Patterned
cutting paper shape

2
Pink

3
Patterned

4
Turquoise

5
Patterned

Cutting paper segments

Fold sequence 21

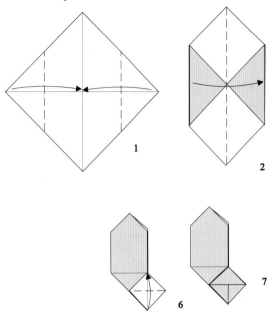

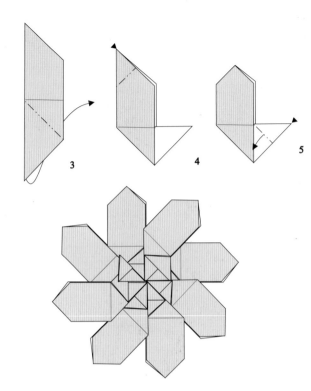

CELTIC DOG'S HEAD PICTURE (see page 45)

Materials

Blue and gold box frame (21 x 23cm)
17.6 x 19.1cm piece of 3mm foam board
A4 sheet of gold paper
8.6 x 10cm piece of gold paper
17.6 x 19cm of blue paper
7.6 x 9cm piece of blue paper
13.6 x 15cm piece of ivory paper
Matching full-fold stamp
Cobalt blue dye ink pad
Pyrography iron
Graphite paper
Piece of thick smooth board
Cutting papers
Spray adhesive

Method

Cut three patterned, one plain pink and one plain turquoise star-shapes from the cutting paper. Cut two of the patterned shapes and the two plain shapes into eight segments each.

Photocopy diagram 39 and build up the background of the mandala. Start by glueing the patterned star- shape (shape 1) in the centre, then, working around the design, secure eight pink segments (shape 2), eight patterned segments (shape 3), eight turquoise segments (shape 4) and the final eight patterned segments (shape 5). Cut away the exposed parts of the original paper pattern.

Cut one plain pink, one plain turquoise and two patterned star-shapes from the cutting paper sheet. Cut the edge away from one of the patterned shapes. Make four mountain folds across the points of each star-shape, then make eight cuts on each shape from the valley between each point down to 0.5cm from the middle.

Glue the pink shape in the centre of the mandala, then glue the blue shape on top so that its points are over the valleys of the pink shape. Glue the large patterned shape on top with its points aligned with those of the pink shape. Finally, glue the cut-down patterned shape centrally on top.

Cut an aperture 16.9 x 15.4cm in the centre of the foam board, then cover the board with gold paper.

Use the matching rubber stamp and cobalt blue ink to create a random pattern on the front of the large sheet of blue paper.

Enlarge diagram 35 to make a full-size pattern. Referring to the instructions on page 6, trace and burn the design on to the ivory paper.

Use spray adhesive to layer the stamped sheet of blue paper, the paper burn, the small piece of gold paper, the small piece of blue paper, the mandala and the gold-covered foam board on to the backboard.

Mount the completed picture in the frame.